Also by MAXine Atwater Ellman

CAPITAL TALES
True Stories about Washington's Heroes, Villains & Belles *

1996 Mercury Press, Washington, D.C.

WASHINGTON REVEALED
(Special Interest Sight Seeing Guide)

1992 John Wiley & Sons, New York

ANOTHER PARIS
Guide to lesser-known treasures & pleasures *

2005, Origin Books, Santa Rosa, CA

ROLLIN' ON
A Wheelchair Guide to U.S. Cities

1978, Dodd, Meade & Co., New York

* *Available on Amazon.com*

Watercolor Dreams
words, pictures, color notes

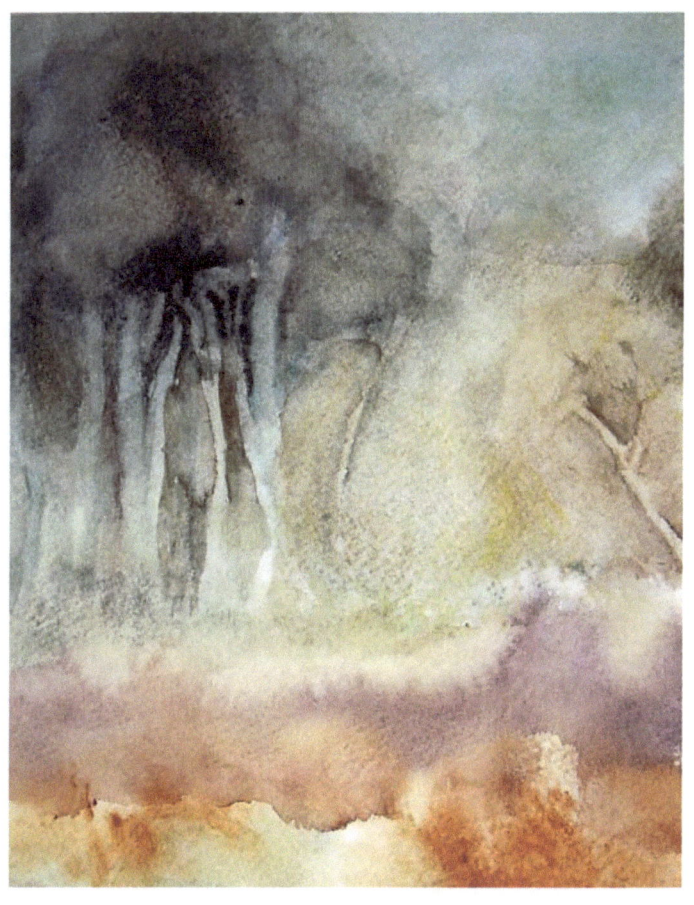

By Maxine Ellman

Cataloging Data

Atwater, Maxine (1933-)
　Watercolor Dreams: words, pictures, color notes

Watercolor Dreams: words, pictures, color notes

Copyright (c) Maxine Atwater 2007

All rights reserved. This book may not be reproduced nor transmitted in any form nor by any means, electronic, mechanical or other including but not limited to photocopying, recording or by any information storage or retrieval system without written permission from the author, except for the inclusion of brief quotations in a review.

Published by: Mercury Press
　　　　　　　320 Gemma Circle
　　　　　　　Santa Rosa, CA 95404, USA
　　　　　　　707-537-0419

ISBN 978-1494276676

*In real life, I will never see the scenes that I've painted.
Reality has its flaws, after all.*

Contents

Introduction	1
Sunrise of the World	4
Blue Ice, Sepia Woods	6
Life's Road	8
Valley of Fire	10
Haunted Woods	12
Lost Land	14
Night's Chamber	16
Waterfall Room	18
Forest Behind Glass	20
Sea Foam Cushions	22
Stone Palace	24

Galactic Passage	*26*
Pink Frosting	*28*
Twilight Tree	*30*
Ice Capades	*32*
Rainbow Finale	*34*
Order Form for Prints	*37*

Watercolor Dreams

Watercolor Dreams brings to life the wonder we felt as children when fairy wings brushed our cheeks and sprinkles of stardust fell from magic wands.

Fantasies that once filled our imagination as we wished upon stars, now take new forms. Real world colors and shapes replace the images that appeared in crystal balls as *Watercolor Dreams* brings imagination and reality together.

This is because as I begin to paint, I remember scenes like a mountain, waterfalls or forest.

The flowing paint sparks imagination which embellishes these real world images – guided by intuition and undefined feelings. Upon seeing the result, I look for the words that capture the feelings expressed. Could that be a cave filled with gleaming treasure, a waterfall with a secret room, a magical forest ?

To explain the paintings to myself I make up vignettes, allowing the child in me free rein to shine light on mysteries, adventures and wonder.

To all this I add a dash of color notes insisting that hues painted parade with their labels showing. But then who could resist the chance to have *Night* lumber into his cave for *Umber* slumber or to relish the triumph of *Sepia* woods over *Cobalt Blue* ice ?

Like me, I hope you find *Royal Amethyst* passion and the wonder of childhood in each *Watercolor Dream*.

- - - - -

About the creator of *Watercolor Dreams*

Impressionistic painter Maxine Ellman, the author of seven books, began painting in 2003. To develop her skill in color harmony, she has studied more that fifty books and applied her knowledge to over one hundred artworks.

In her development as a colorist she acknowledges the influence of authors Jeanne Dobie, Nita Leland, Stephen Quiller and Jim Kosvanec. In helping her to develop technique and design expertise she credits authors Edward Betts, Jeanne Carbonetti and Linda Kemp.

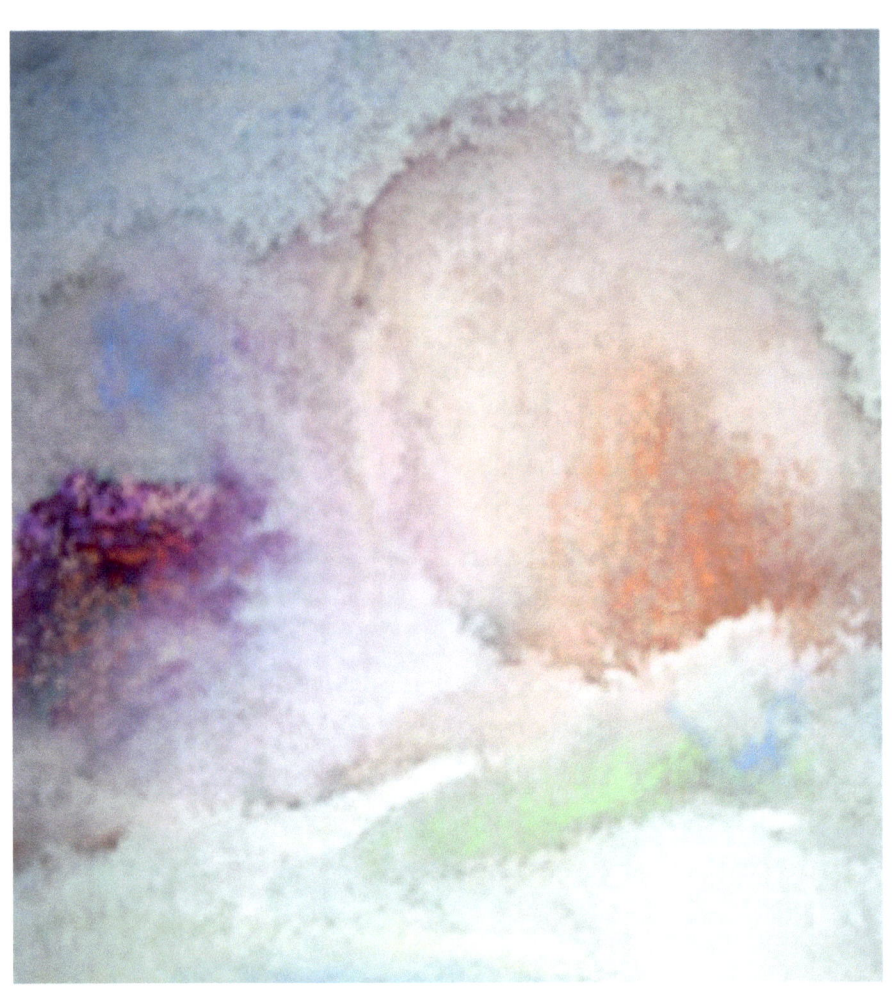

Sunrise of the World

In those early days the world opened like an *opera rose* blossom new and fresh. The air breathed us with clarity and aliveness. This transparency allowed us to perceive the full spectrum, including the invisible.

Abundance and possibilities unfolded their arms as we floated an inch above the *burnt sienna* earth.

And music resounded. First the bells tinkling their silver sound then the full orchestra rising in a resounding hymn. With understood the promise: peace for evermore.

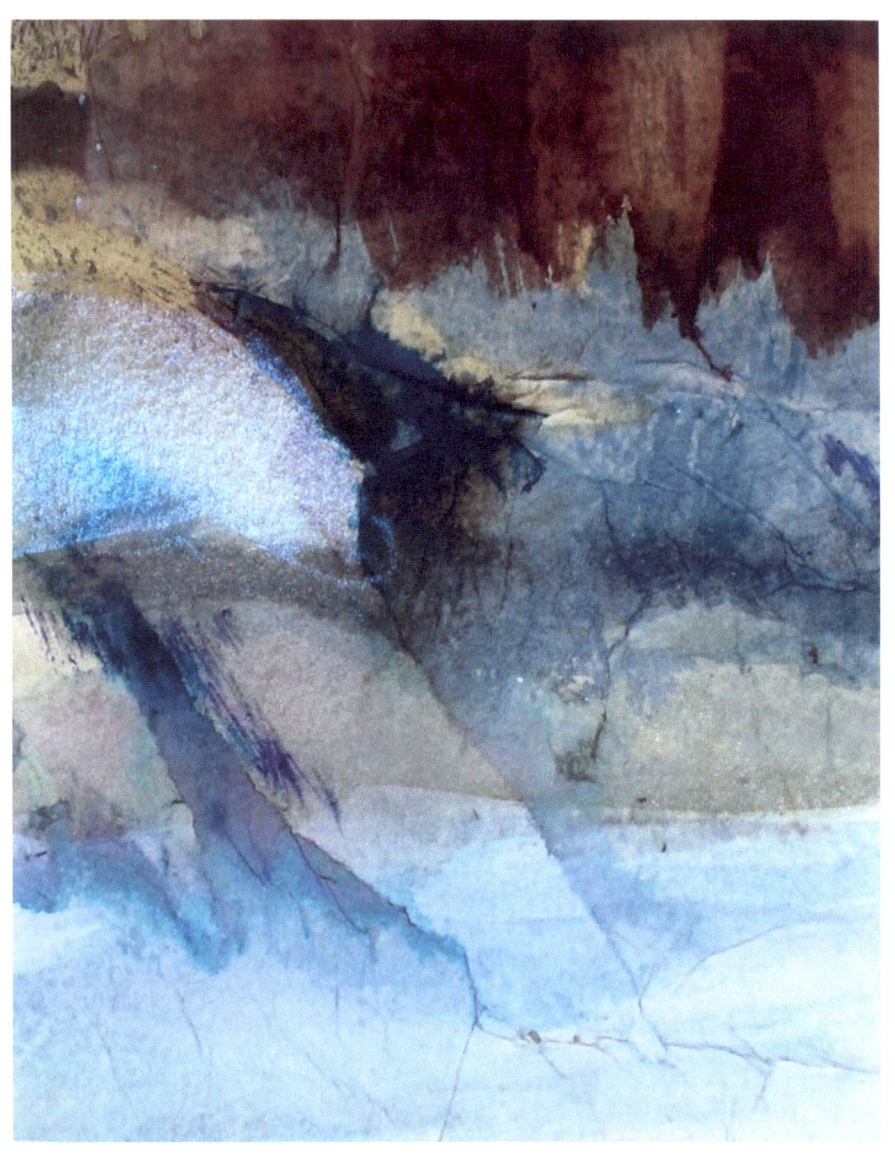

Blue Ice, Sepia Woods

Long ago when *cerulean blue* ice covered the land, the *sepia* woods stood their ground, though buffeted by bergs and floes. Imperious glaciers invaded the blue-black earth, etching crystal mountains with rivers of frosted snow.

But, after eons, the frozen earth relented and the sun came down to the treetops. As the melting water crashed and thundered to the sea, the sun-warmed trees trilled songs of triumph.

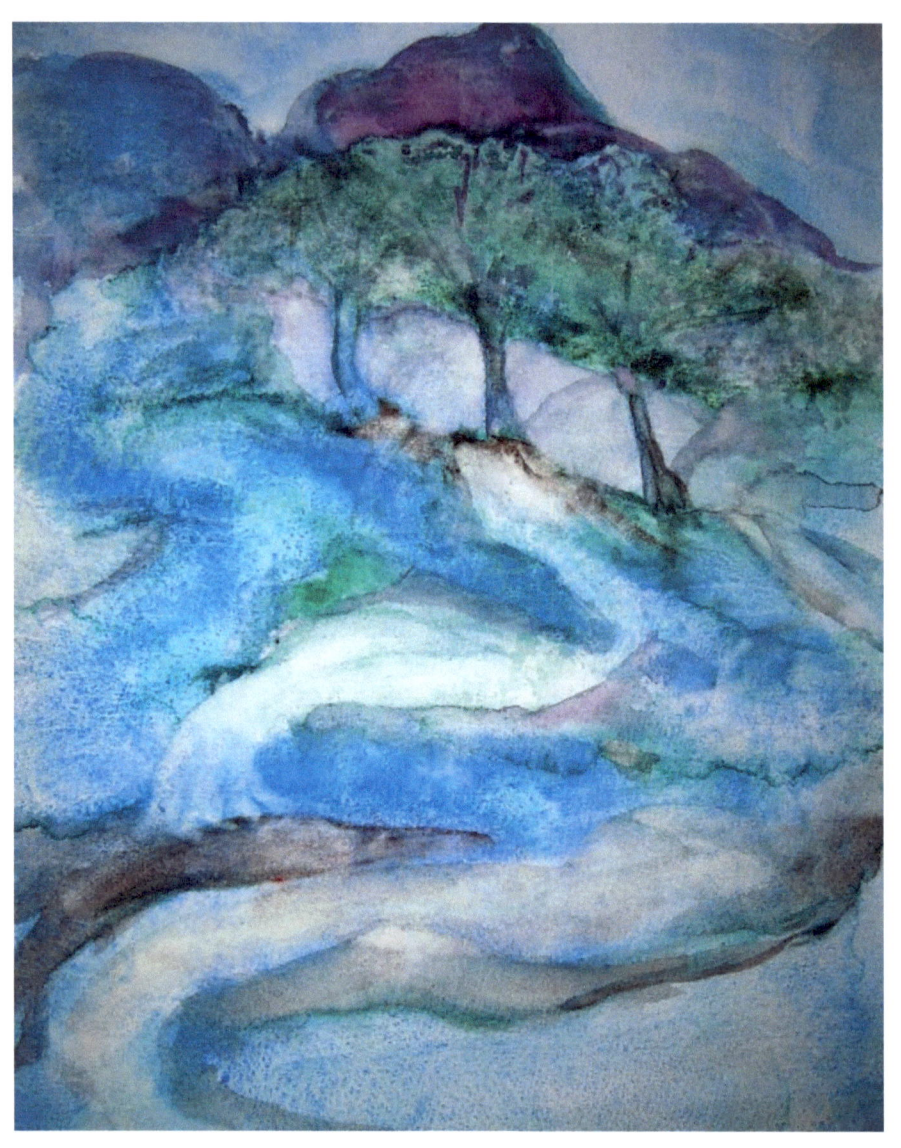

Life's Road

The road, etched between
fringes of *Prussian green* heather,
led to places beyond our wildest dreams.

Ascending our perspective widened
and the world opened up before us.
The row of *ultramarine-violet* trees
at the crest pointed to the future.

Propelled by anticipation we flew,
but then the wonder of being alive
overcame us and we sat down and
wept with joy.

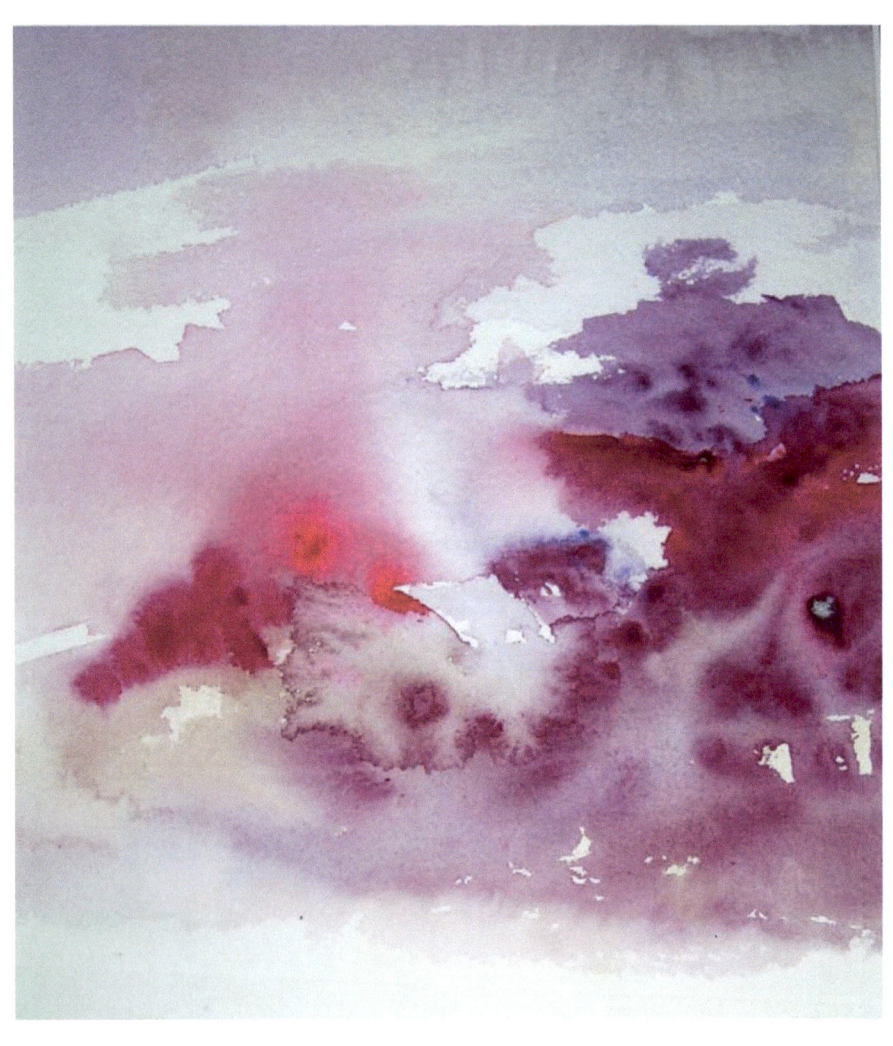

Valley of Fire

It was hard to believe that the sunset painted onto rocks what looked like a roaring *vermilion* fire of *cadmium orange* flares. Flame-like projections lit by the flickering sunlight seemed to emit heat and crackle. At he center of the conflagration molten silver glowed in *iridescent gold* light.

However, before we could toast our marshmallows, *indigo* twilight extinguished the flames and the air cooled.

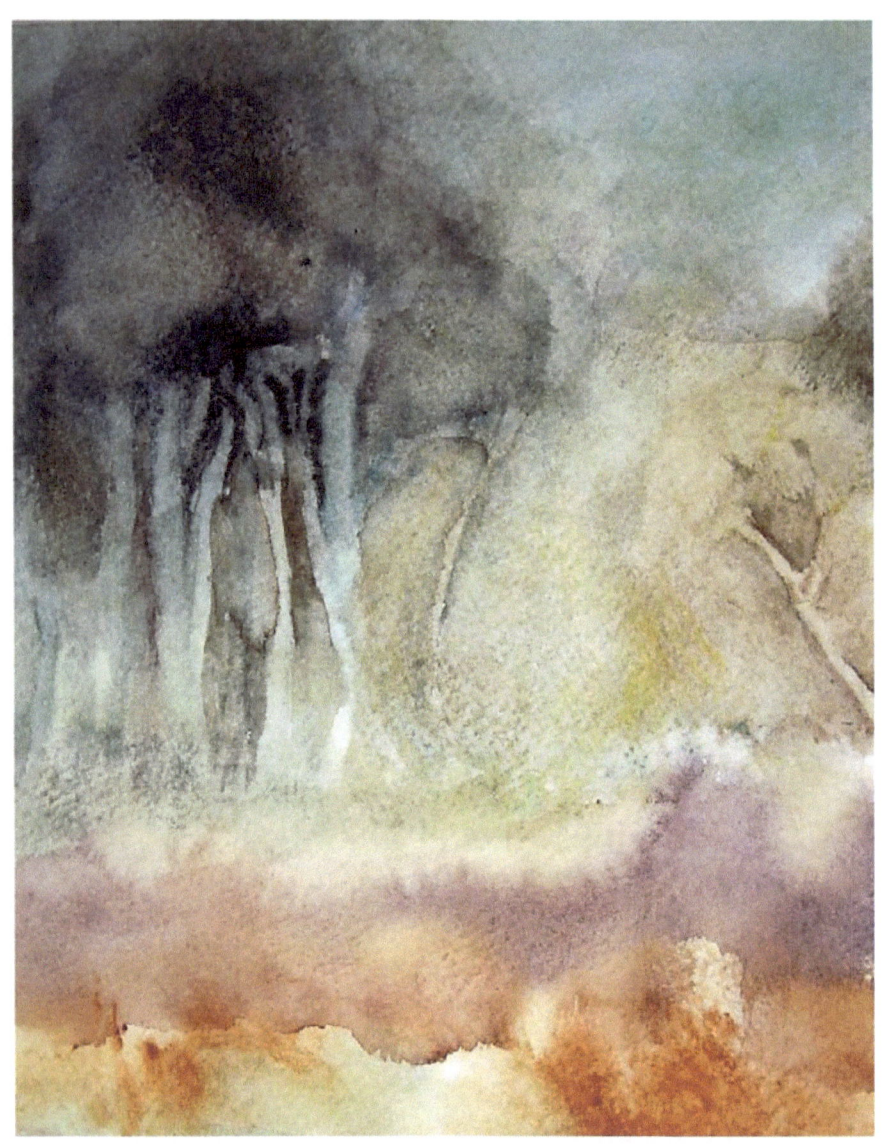

Haunted Woods

Although people warned us,
we ventured across *burnt sienna* fields
into a somber forest of frowning trees.

An *Indian yellow* cypress,
bending toward our destination,
pointed a bony- finger limb
at a panoply of trunks topped by fuzzy grey froth.
Ghost trees loomed like sentinels guarding tombs.

A sudden cold breeze made the leaves whisper
as we, with pounding hearts,
stepped into the *ivory black* gloom.

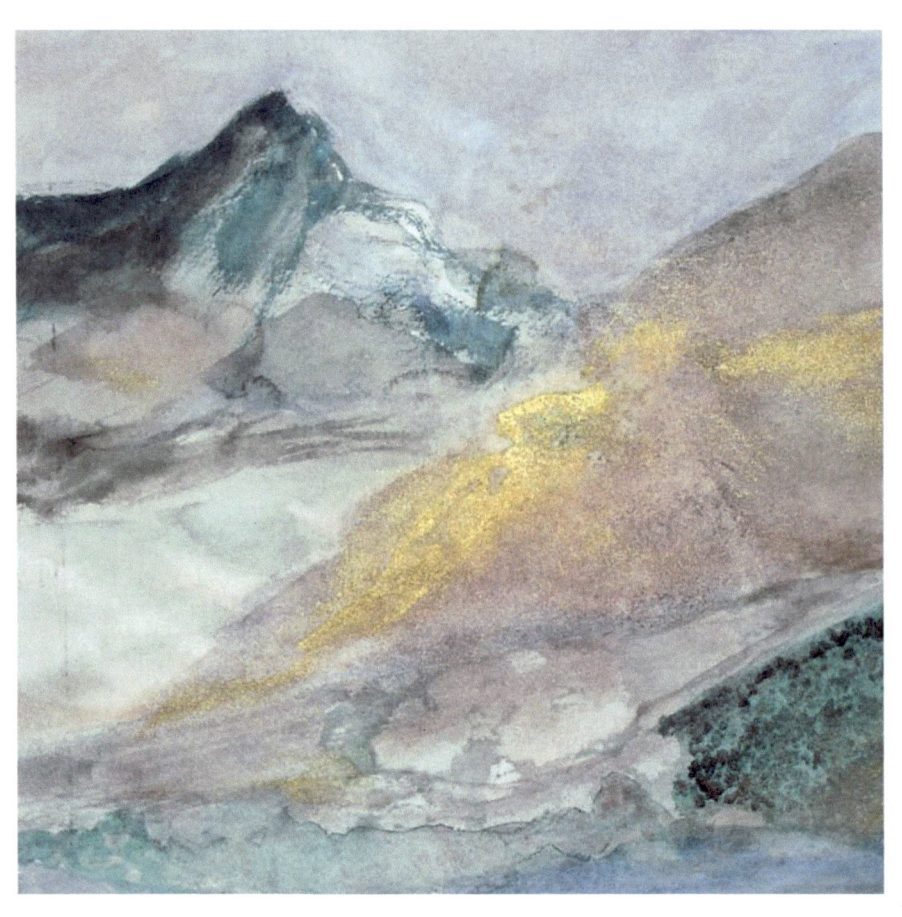

Lost Land

As if in a dream, I glimpse a landscape uncharted on my map. Beyond the spot where the aqua sea melts into mysterious shadows, a dusting of gold and silver shines on cold *terre verte* rocks.

The mist parts to reveal the secret cove glowing in *rose madder* light where the treasure was hidden long ago. Landing my craft and setting out for the site, the wind at my back pushes me forward as my feet skim over the rocks and I fly.

I don't at first see men watching me.

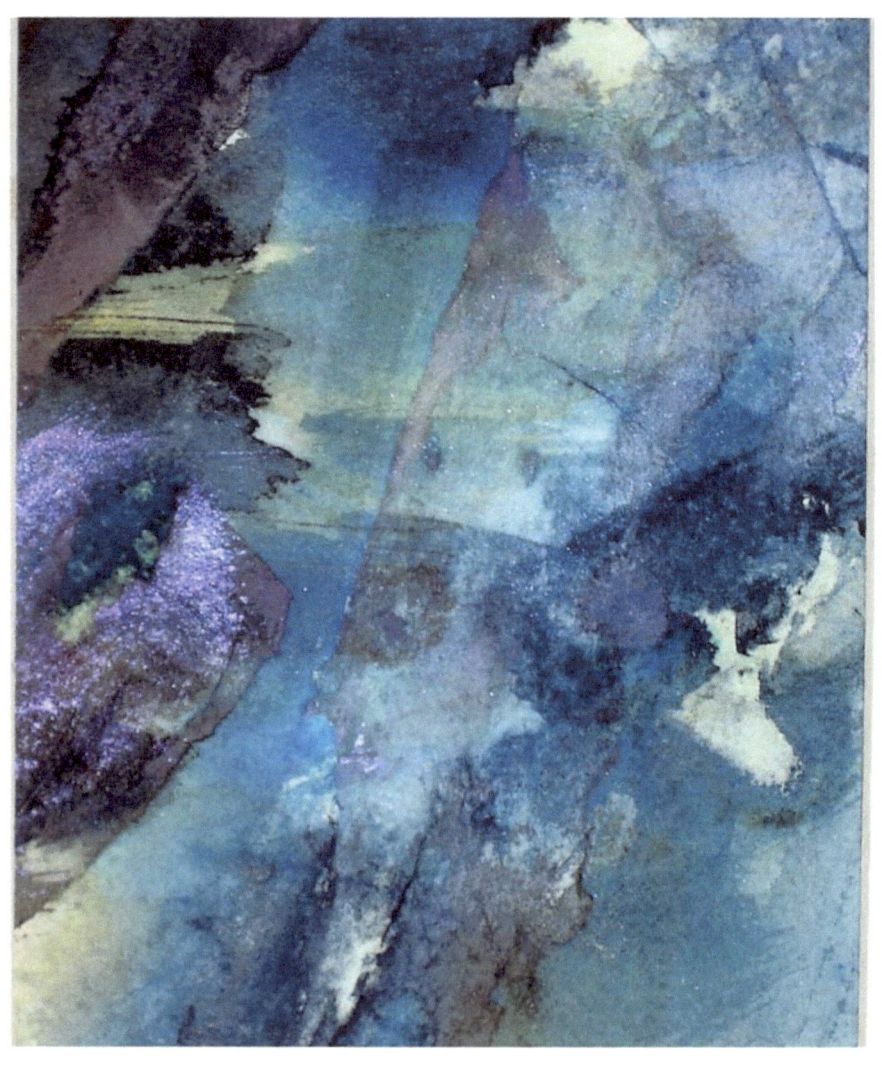

Night's Chamber

Far deeper than the caves explored by man a primeval chamber bids Night "come, sleep."

Night descends, creeping beyond veils of *quinacridone gold*, where rocks glow, lit from within by the alchemist's fire.

Into darkness, across a sea of *cobalt turquoise* jewels Night lumbers to his cave collapsing at last into *umber* slumber.

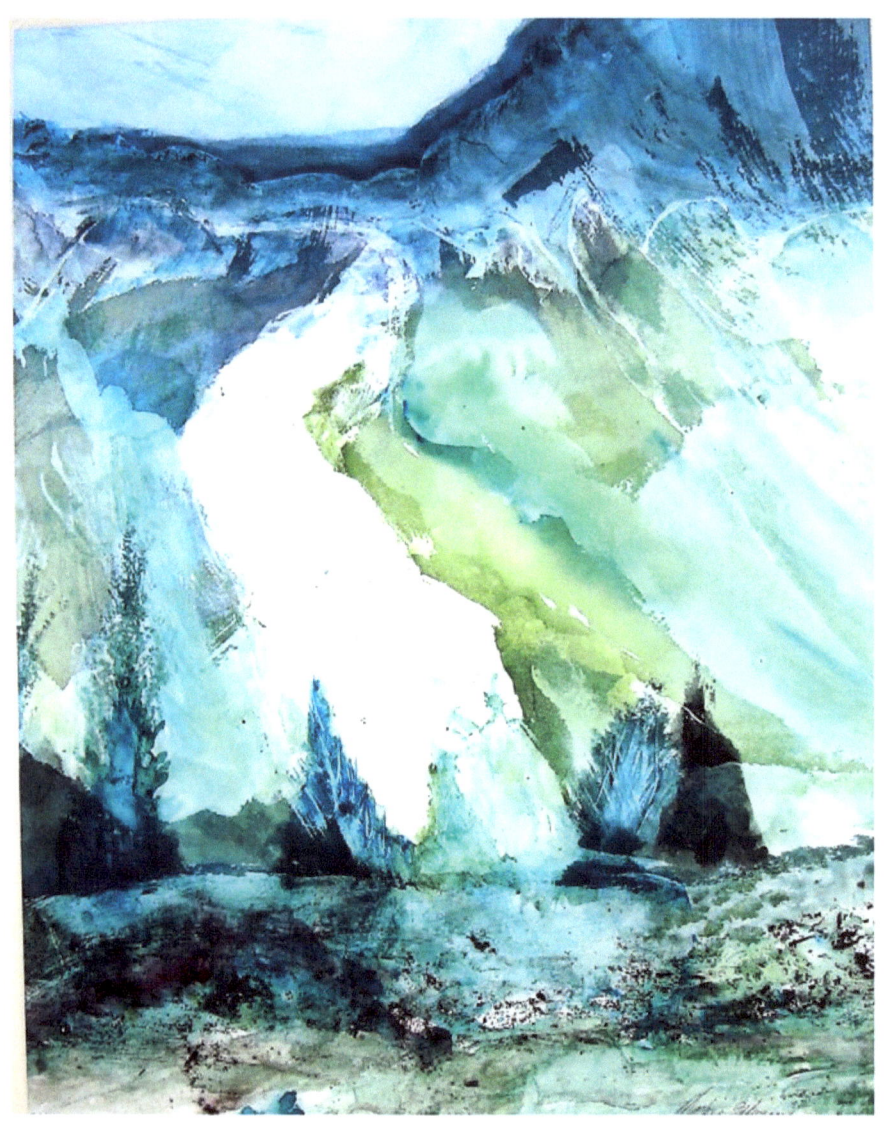

Waterfall Room

Exhausted from our long trek over the *green gold* hillside, we longed for a sheltered place to sleep. Even before we saw the water gushing from above, we heard the sound of the thundering waterfall.

Following the hillside ledge we turned under an *antwerp blue* curtain of water into a cavern. Inside we found dry spaces on rock ledges softened with *Sap Green* moss.

Before we settled down to sleep, however, we stepped into the *Chinese white* spray to enjoy an unforgettable shower.

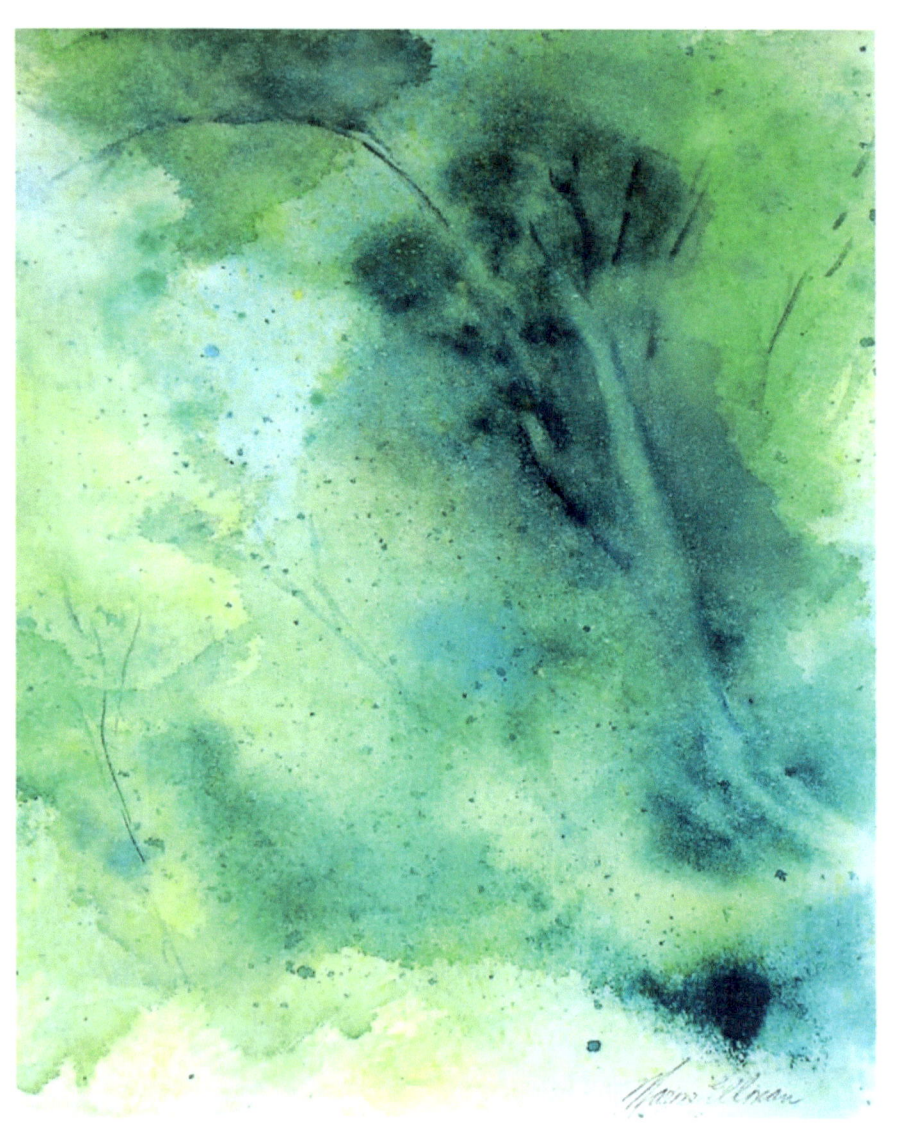

Forrest Behind Glass

Behind the glass panel that screens the forest most people see, hides a *viridian* landscape seemingly painted on velvet. Feathery branches sway and trees, in every known shade of green, shimmer in full wildness.

Venturing to this other woods, we hear the sounds we imagined long ago as children: The forest girl in *Green Mansions* calls. Hiawatha chants as he leads his new wife to his people. Hobbit, bound for his cozy hearth, whistles.

The path curves into mysterious groves where, when the *green gold* leaves shimmer, we hear the flutter of fairy wings.

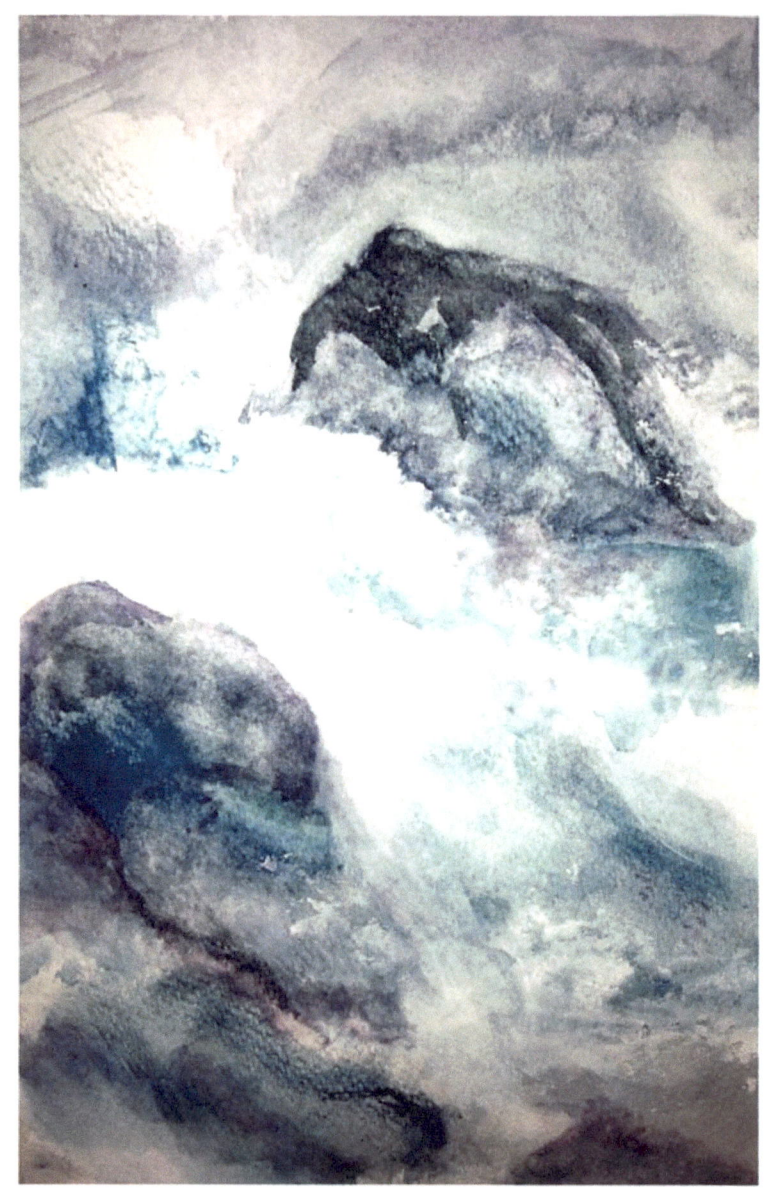

Sea Foam Cushions

We played like water babies riding
the cushions of foam over velvet rocks.

Floating in gossamer sail boats
we flew through *titanium white* spray,
laughing and coasting down shoots of spume.

The sea bathed us in pale *rose madder*
light and *manganese violet* rock shadows.
Like our fish companions we darted,
dove and floated *to* quiet tide pools
resting our heads on pebbles and
dozing in the sun.

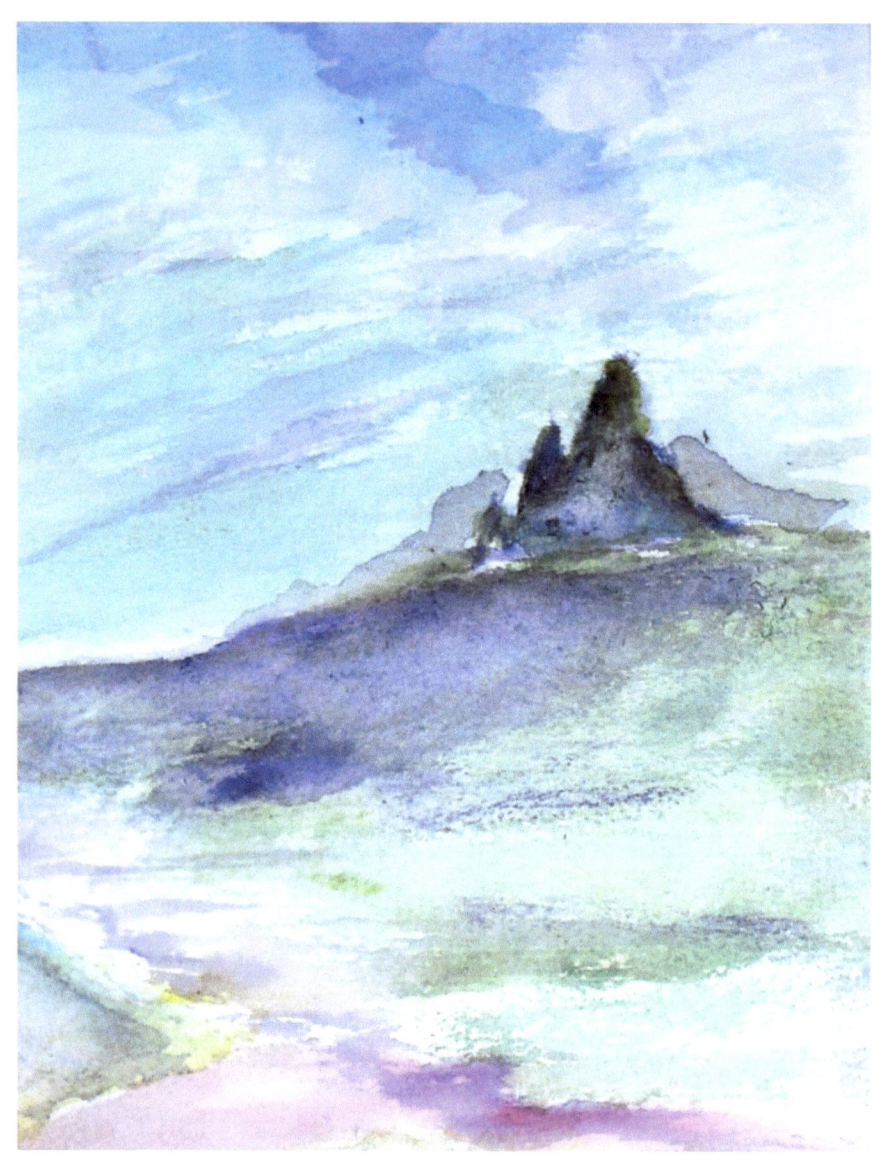

Stone Palace

Tales of the rock-hewn palace hidden
in the valley beyond the *viridian*
mountains fired our imaginations.

But after a long search we despaired.
Then just as we were turning back,
an *aureolin* mist swirling like a halo
illuminated a nearby hilltop.

Climbing to its peak, a *manganes-violet*
landscape leading to a fantasy of domes,
gables and spires unfurled before us. As
we approached the jewel-encrusted
doors of the palace slowly creaked open.

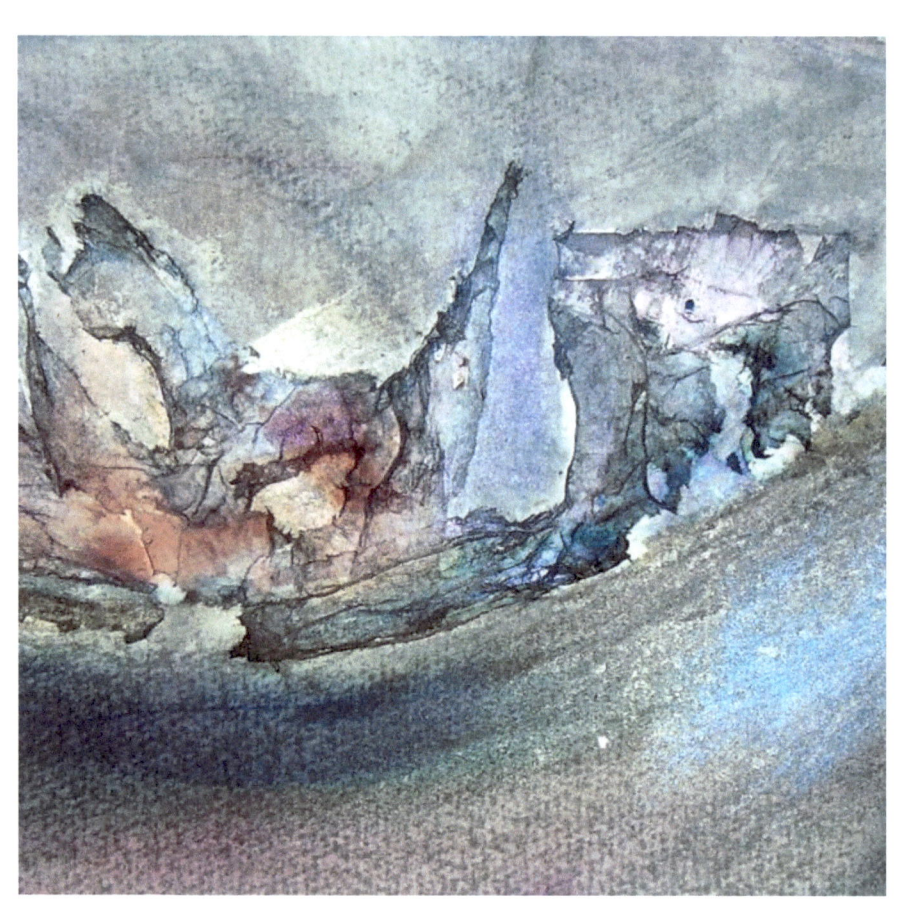

Galactic Passage

Molten metal seas curve around a landscape of gleaming *Payne's gray* mountains dotted with a wild chaos of rocks.

Jewel colors shimmer in the cold, clear light as winds roar across time and space.

Although forbidden, I yearn to land on this uncharted terrain to clamor up its *perylene scarlet* slope to *manganese blue* peaks and from that glowing viewpoint -- behold again my dear Earth.

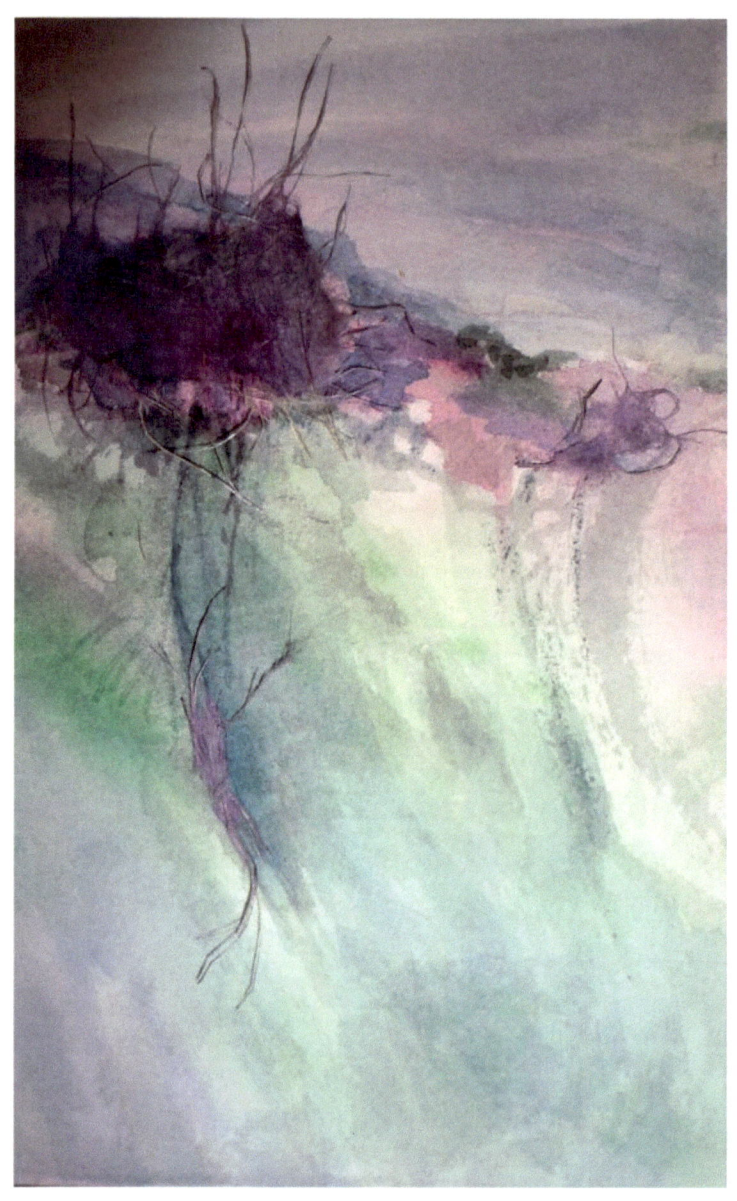

Pink Frosting

Even before we saw the *rose dore* fringe of trees we heard music. The sweet strains of lullabies mingled with childhood memories when light turned everything into rainbow hues.

Pink trees and *cobalt violet* hillsides were common then, as were flowers so brightly colored we had to shade our eyes as if looking into the sun.

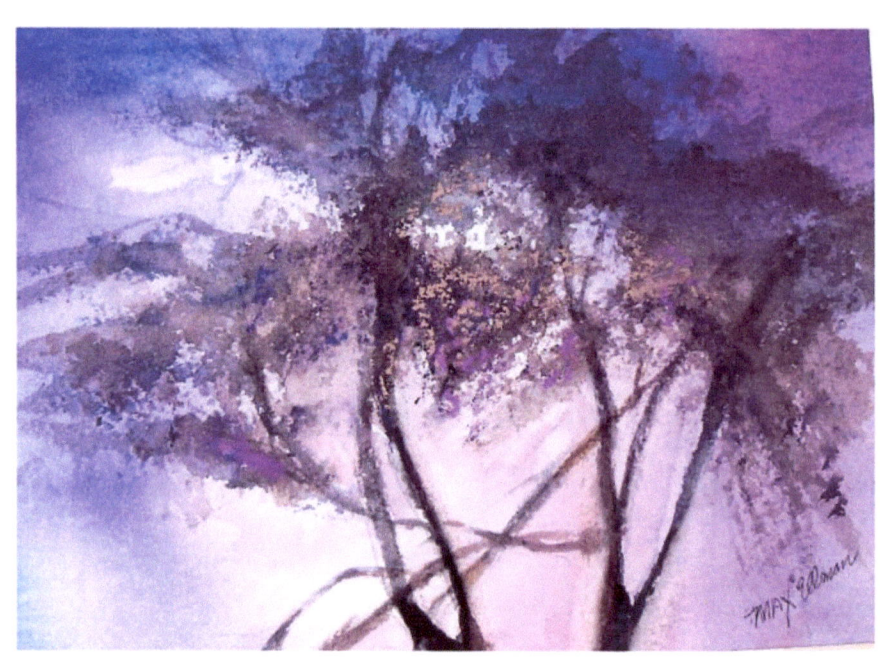

Twilight Tree

The color that comes to mind when one thinks of Africa is either savannah yellow, tropical green or the *scarlet lake* red of flame tree. But only on certain nights does darkest Africa turn *dioxazine* purple. That's because at twilight a gauze of alizarin hues veils the dimming light.

Happening upon this phenomena, we proceeded fully aware that with careless steps we'd be dusted with purple powder and forever changed.

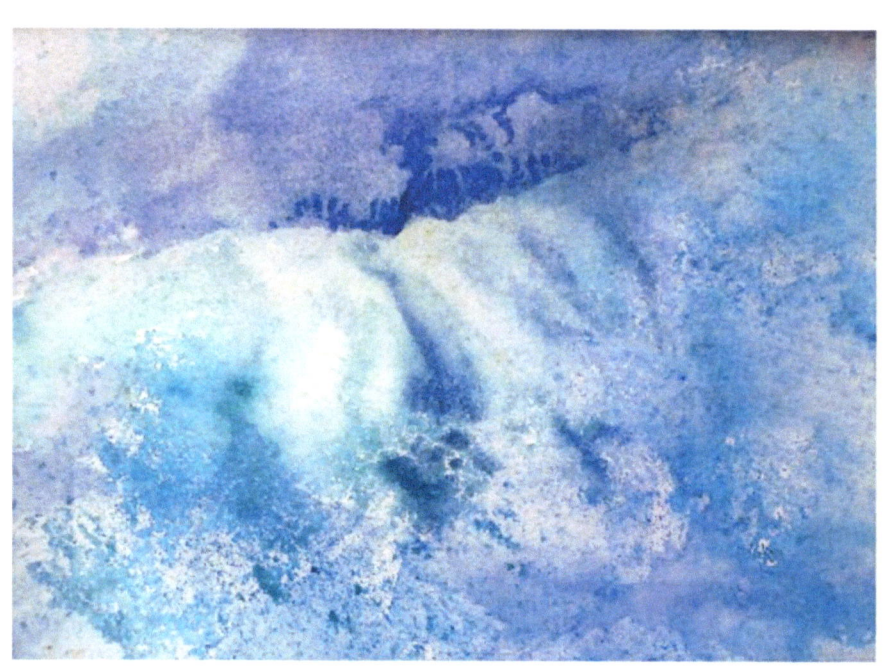

Ice Capades

Just seeing the *manganese blue* ice fields
coated with frost crystals
made us snuggle deeper into our furs. Trees
outlined in silver tracery against
the sky seemed to shiver.

When we spotted *Chinese white* snow caves
and icy tree houses we pictured
small creatures nestled under leaves. More
specifically we hoped to bring to life
a favorite Christmas card image of
birds nibbling *cadmium red* berries or
hares peeking out from the blankets of snow.

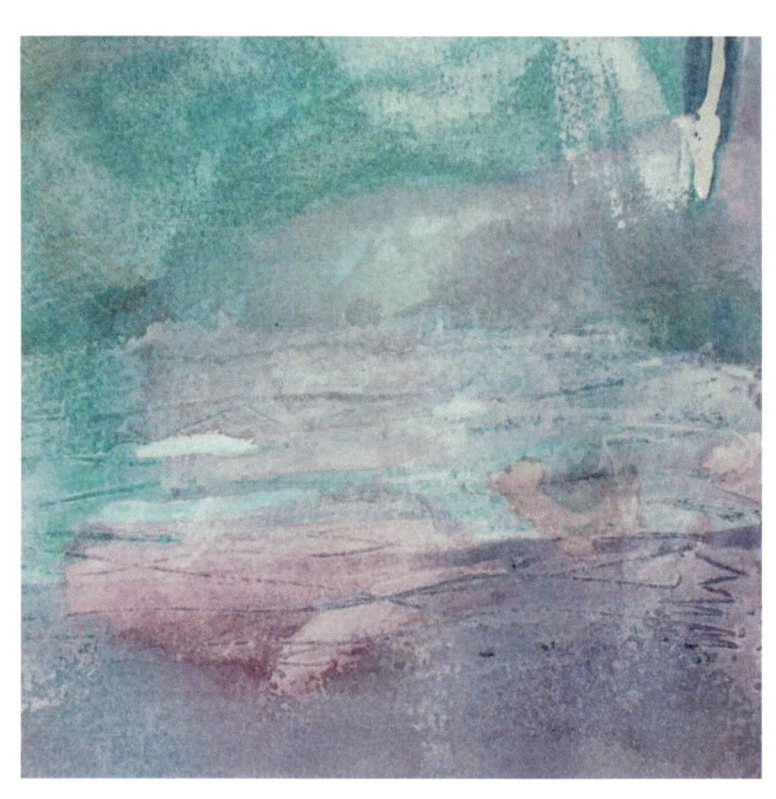

Rainbow Finale

When the rainbow fades away into mist
the prismatic colors we see bound in the arc
go their separate ways.

Each shade – bold and free – paints itself
on nature with little regard for photo realism

Thus, in this altered valence, when
initiates come upon *opera* pink pools,
thalo purple rocks and *Windsor turquoise* hills
they see the exuberant colors as unremarkable.

To those who do, they respond: *"green grass
and blue ponds are somewhat mundane,
don't you think?"*

When paintings talk...

Through their words they spark within you untapped feelings of mysteries and longings. Now in addition to experiencing the narratives accompanying each *Watercolor Dream* painting you can share the experience by owning archival prints.

------------------ Order form ------------------

11 x 14" matted print $26 each Plus $3.50 shipping & handling
$5.50 for two

Send me the artworks which I've check marked:

() *Sunrise of the World*

() *Blue Ice, Sepia Woods*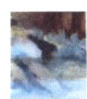

() *Life's Road*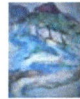

() *Valley of Fire*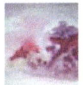

[Continued next page]

() Haunted Woods

() Lost Land

() Night's Chamber

() Waterfall Room

() Forest Behind Glass

() Sea Foam Cushions

() Stone Palace

() Galactic Passage

 [Continued next page]

() *Pink Frosting*

() *Twilight Tree*

() *Ice Capades*

() *Rainbow Finale*

Name_____

Address_____

Make check to: MAXine Ellman
Mail to: 320 Gemma Circle
 Santa Rosa, CA 95404

See her other artworks at www.MAXineEllmanArt.com

www.ingramcontent.com/pod-product-compliance
Lightning Source LLC
Chambersburg PA
CBHW040925180526
45159CB00002BA/620